The Lucky Greyhound

Beverly Helmbold Erschell
author and illustrator

Victoria Grimme, co-author
Barbara Sweet, co-author
Audra L. Rose, advisor

Cincinnati Book Publishing

The Lucky Greyhound

Beverly Helmbold Erschell, author and illustrator
Barbara Sweet, co-author
Victoria Grimme, co-author
Audra L. Rose, advisor
Sue Ann Painter, editor
Bob Kelly, graphic designer

Copyright © by Beverly Erschell

Published by Cincinnati Book Publishing

Anthony W. Brunsman, president
Sue Ann Painter, executive editor
Anna Lapp, editorial and production assistant
Amelia Stultz, editorial and production assistant

www.cincybooks.com

ISBN – 978-0-9894271-6-6
E-book ISBN – 978-0-9894271-7-3
Library of Congress Control Number: 2013947958

Printed in the United States of America
First Edition, 2013

For additional copies, visit cincybooks.com
or call 513-382-4315

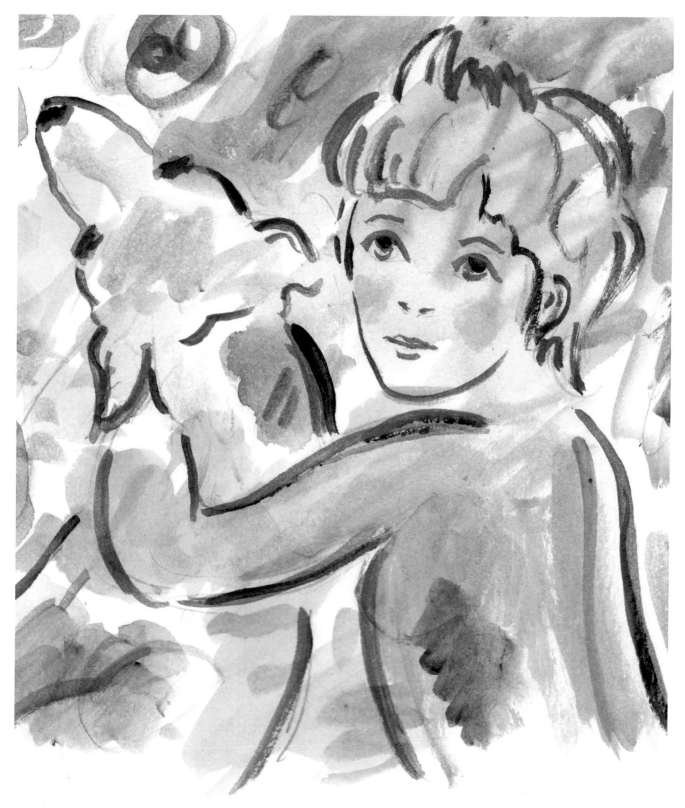

The Lucky Greyhound

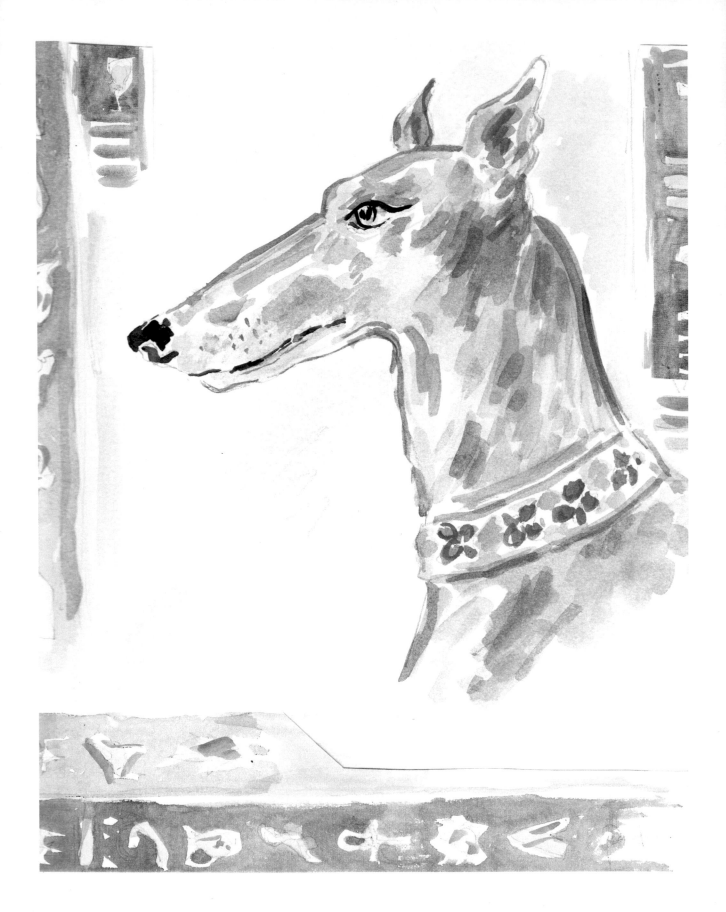

INTRODUCTION

The greyhound is one of the oldest canine breeds. It evolved in Eastern Europe or Eurasia from the wolf or jackal. The name means "great," rather than the color grey. This breed comes in several colors and combinations.

In ancient Egypt, greyhounds were revered by the pharaohs and their courts. They developed a regal look. When the dogs died, they were buried in the pharaohs' tombs. The elegant greyhound makes a fine pet, even though most are full-grown when adopted. Many of them are bred to enter competitive racing and had earlier careers as racing dogs. After the cheetah, the greyhound is the fastest-running animal on earth.

Dog-track racing has been popular in the United States since the 1920s. Most tracks are in warm-weather locations because these dogs cannot tolerate cold weather. Their hair and skin are too thin.

Greyhounds are docile dogs except when racing or hunting. In medieval times, hunting game animals on horseback with greyhounds—called coursing—was a popular sport with the landed gentry. Coursing events were held on country estates in England, Ireland, and Wales. Renaissance paintings depict these graceful animals hunting with their masters or walking alongside elegantly attired ladies.

Greyhounds do not hunt by scent; they are sight hounds. Superior speed and keen eyesight enable them to keep a deer or hare within view and range. The greyhound can run as fast as forty-five miles per hour.

Greyhounds are gentle, intelligent dogs. When they become too old to race, many are adopted as pets. National and local greyhound adoption groups help match retiring racing dogs with good homes.

The Lucky Greyhound is the true story of Maple, a failed racing greyhound, who eventually found a happy life with two loving families. She was lucky, and so were her humans.

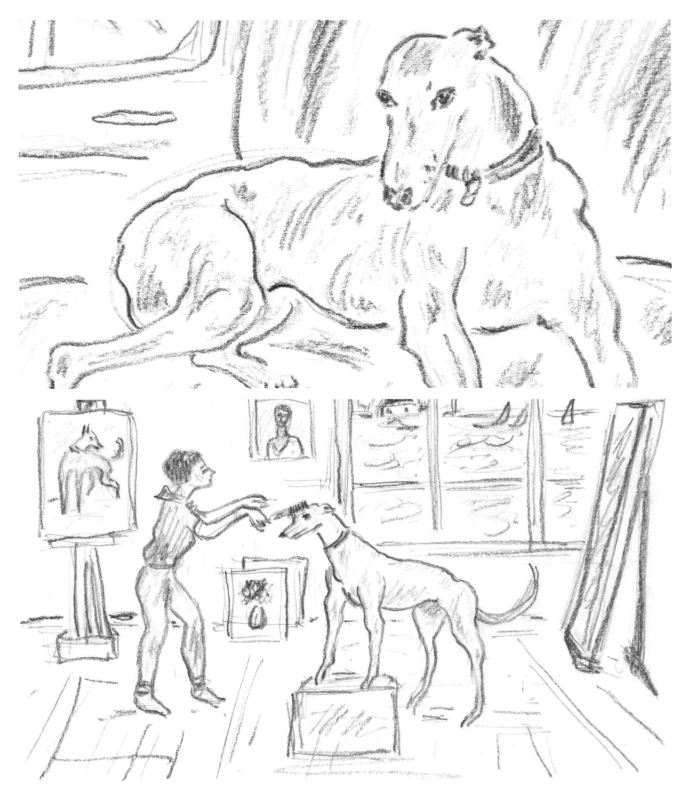

Maple awoke wondering where she was. She stood, stretched, and looked around the room. It was filled with paintings and art supplies, so she must be in Beverly's house.

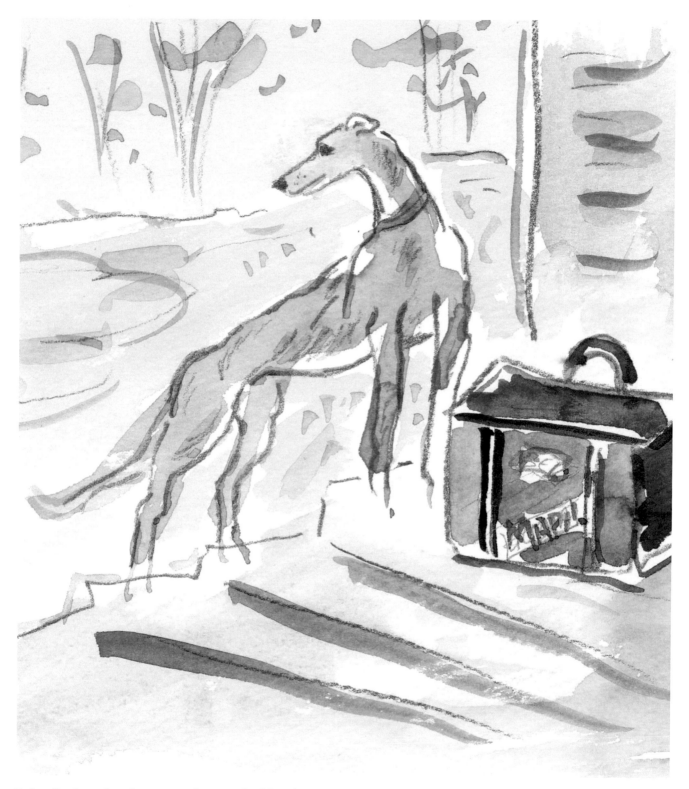

Maple is a lucky greyhound. She has two adoptive families: Beverly the artist and Audra the nurse. She travels between their homes, spending a month or two in one, and then moving to the other.

Some greyhounds are bred to show, but Maple was bred to race. Her long, sleek body is aerodynamically designed for speed. The greyhound is not flatfooted like other dogs. It springs forward on its toes.

Sloped forehead
does not block air

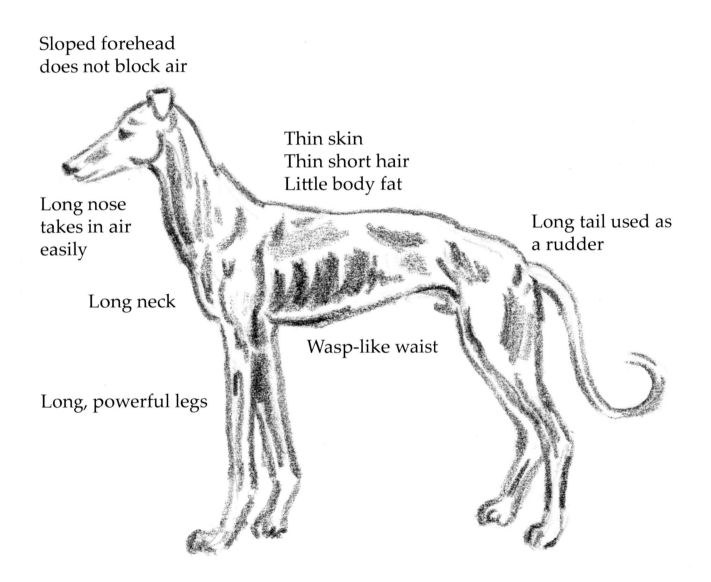

Thin skin
Thin short hair
Little body fat

Long nose
takes in air
easily

Long tail used as
a rudder

Long neck

Wasp-like waist

Long, powerful legs

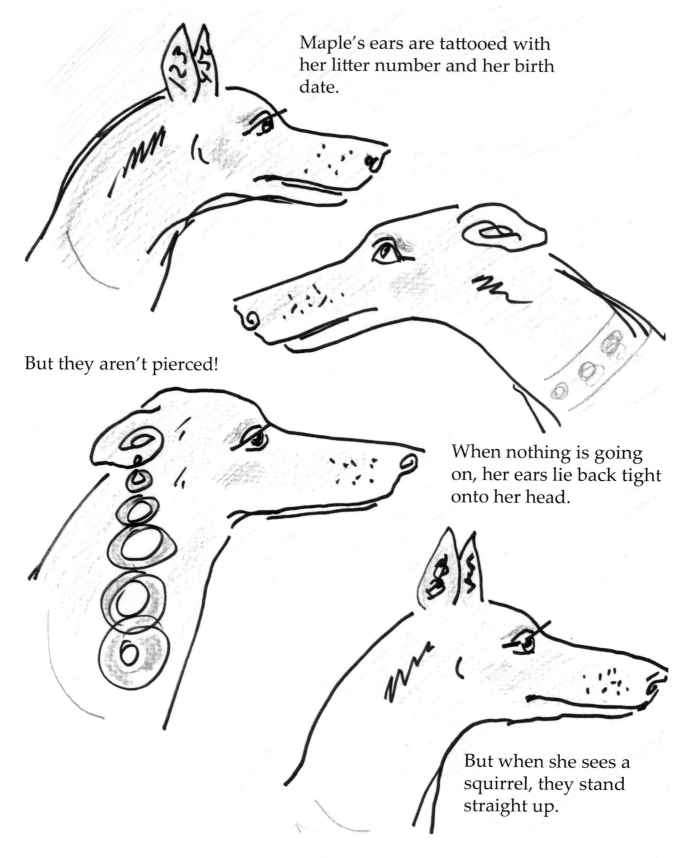

Maple's ears are tattooed with her litter number and her birth date.

But they aren't pierced!

When nothing is going on, her ears lie back tight onto her head.

But when she sees a squirrel, they stand straight up.

5

Maple was born into a family of "working greyhounds," whose jobs were winning races at a dog track. When she was big and strong enough, she was trained to run around a track, racing against other greyhounds. Her job was to chase after a mechanical rabbit and finish ahead of her family and friends. Maple thought this was all kind of silly.

Maple got along well with human trainers and the other dogs in her kennel, but she had problems with racing. She refused to jump quickly through the starting gate when it opened. She politely waited for the other dogs to lead.

She had the physique, but not the personality to compete. So she never won a race. Maple lacked a burning desire to be the leader or to catch the metal toy animal. She was happy doing her own thing.

Everyone loved Maple. But after two years without a win, Maple's owner decided to put her up for adoption. It was scary like a job interview. What was to become of her?

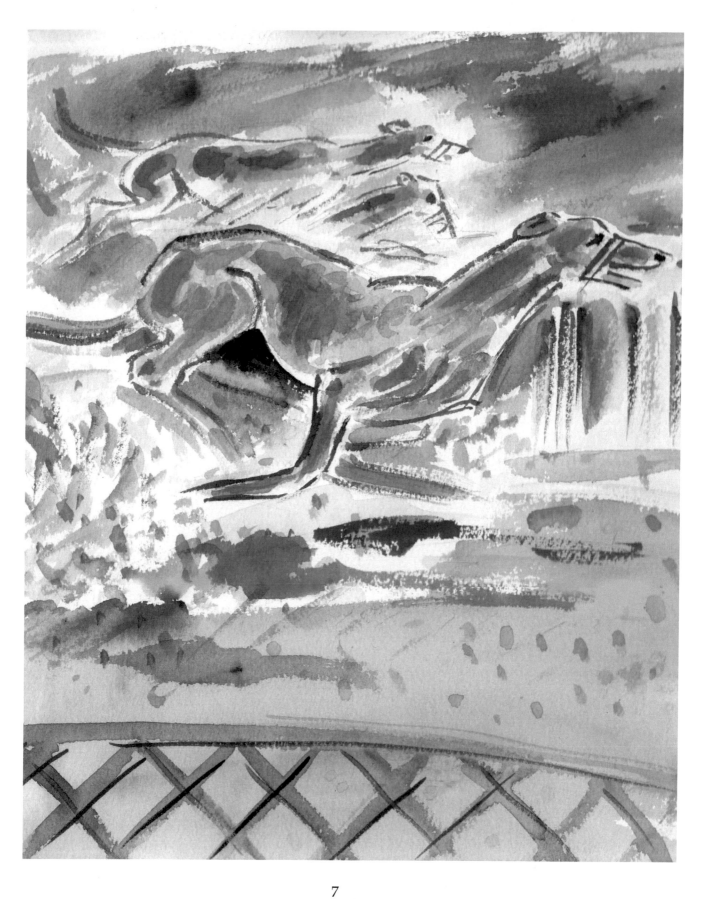

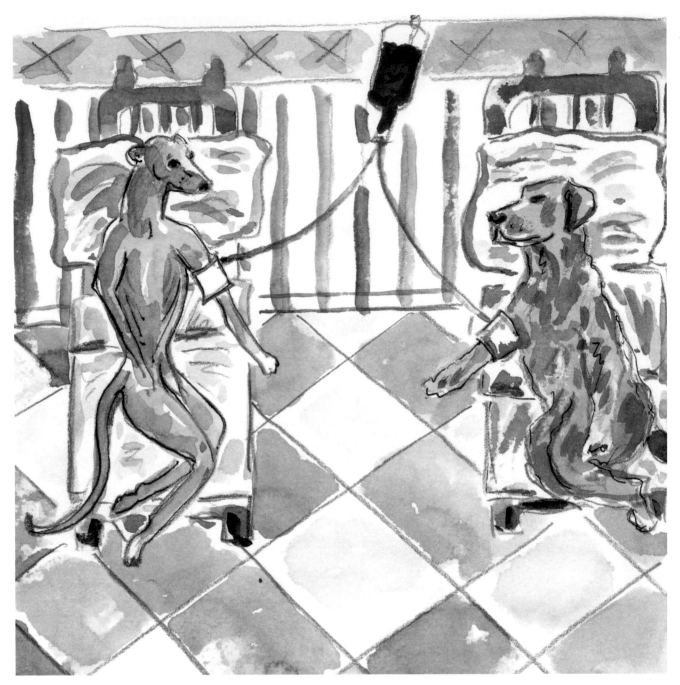

News of Maple's availability traveled to an animal clinic in Northern Kentucky. Maple was in luck. The veterinarian there needed a dog to donate blood to sick and injured animals.

Maple was just the right dog for the job. Greyhounds have higher levels of red blood cells than any other breed, so they have become universal blood donors. Dr. Francine adopted Maple, and her good luck began. In this job, she saved many lives.

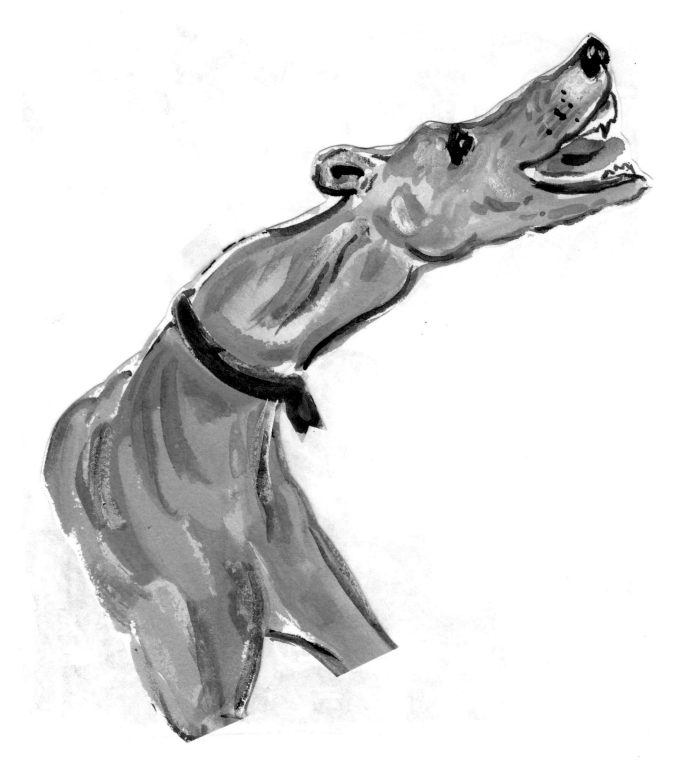

Maple is a friendly animal; she likes people. But she has a certain smile that made some people at Dr. Francine's afraid of her. They thought she was snarling at them. But it's a smile.

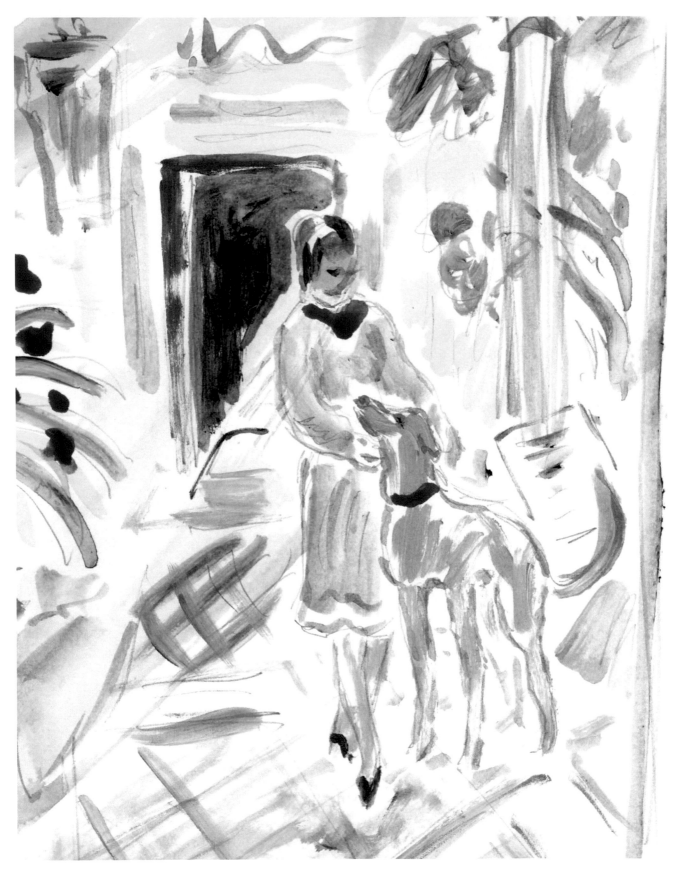

Maple has some endearing and peculiar characteristics. Sometimes she clacks her teeth like a castanet and sticks out her neck like an alligator. When she's happy, she curls her lips.

Maple is such a friendly, outgoing dog that Dr. Francine felt sorry for her, being kept indoors at the clinic most of the time. She offered to give Maple to Beverly, an artist who would give the dog a real home.

One of Dr. Francine's lab technicians, Audra, also loved Maple, but she lived in an apartment with no yard. So Beverly and Audra decided to share Maple. Maple is lucky with so many people to care for her.

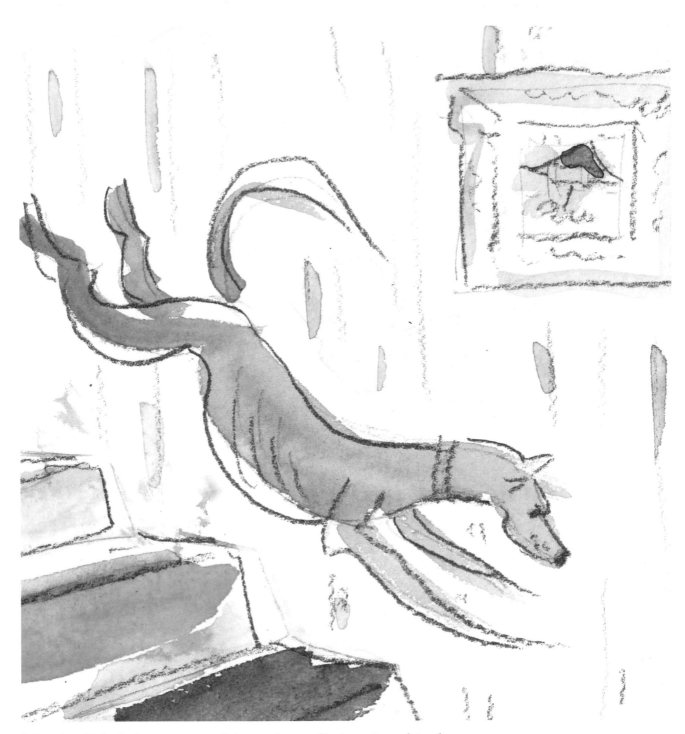

Maple didn't know anything about living in a big house.

She was terrified of wooden stairs and would shake all over when Beverly asked her to go up or down. Then one day she ran up the stairs, turned around, and ran right back down.

Hooray—she had learned a new trick!

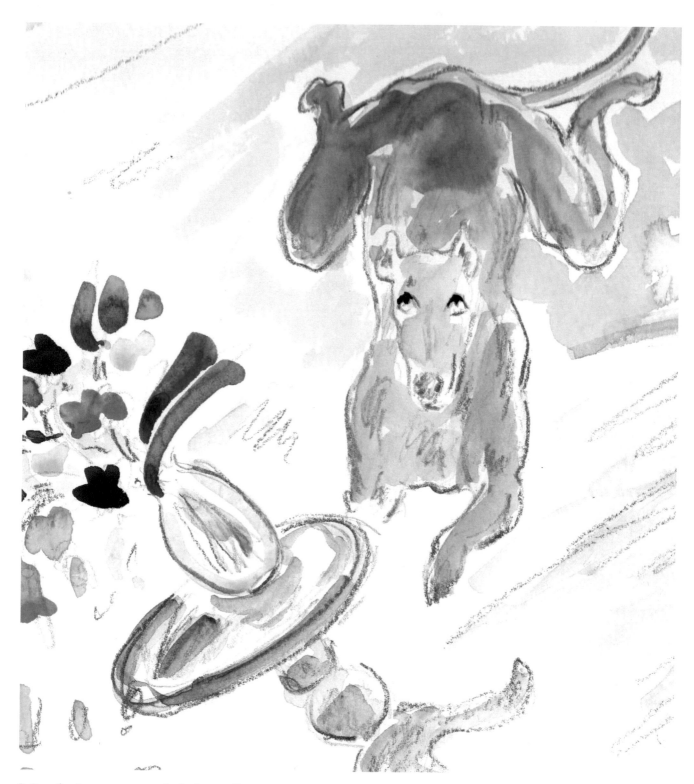

Maple is so graceful that she can run around furniture and not knock over a thing. Except one day she misjudged a table.

It's hard to stop once you're in midair.

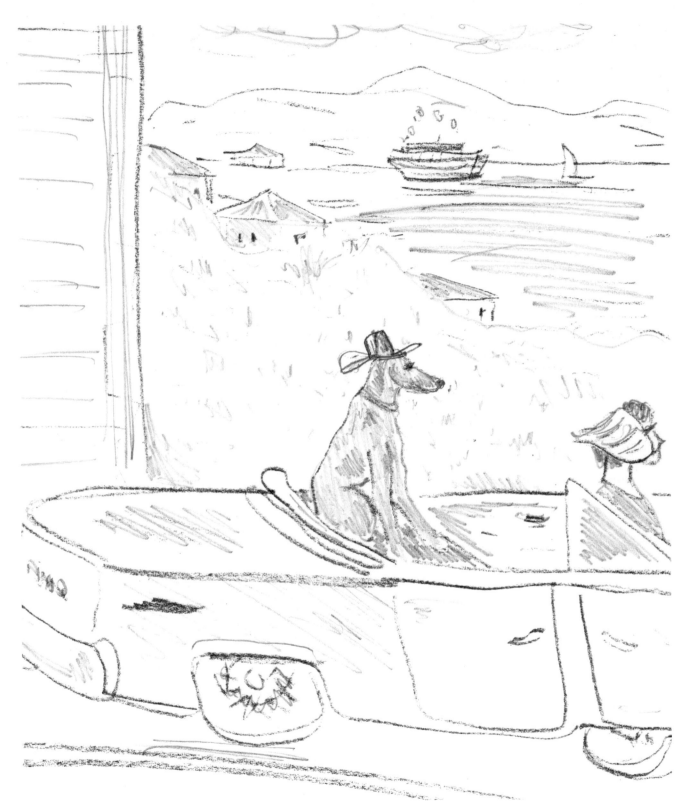

Audra and Beverly take Maple everywhere. Maple loves to ride in Audra's open-air car.

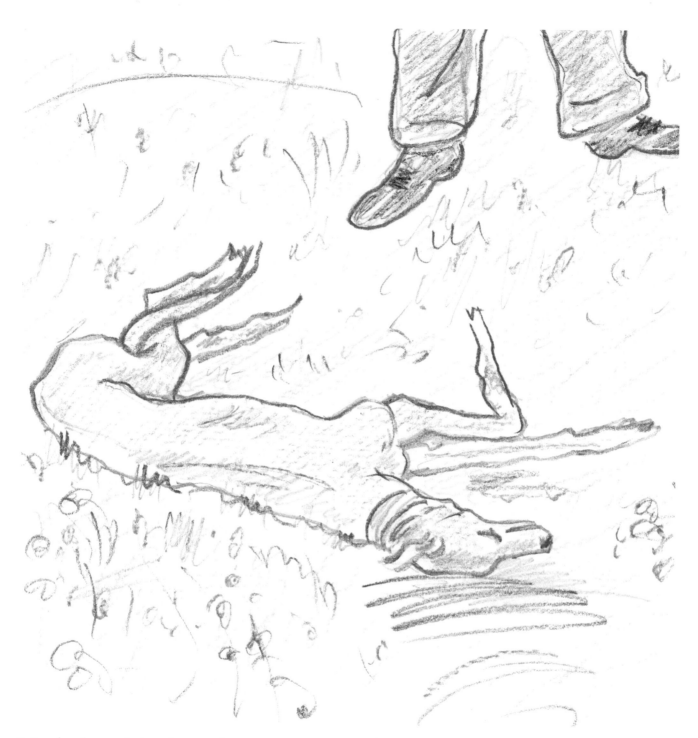

Maple doesn't bark much or even get up when someone comes to the door. She really can't be bothered. It's not her job.

One day, Ed, Beverly's mailman, nearly stepped on Maple. She was lying peacefully on the doorstep, and he mistook her for a carpet. Ed said he wished other dogs behaved more like Maple.

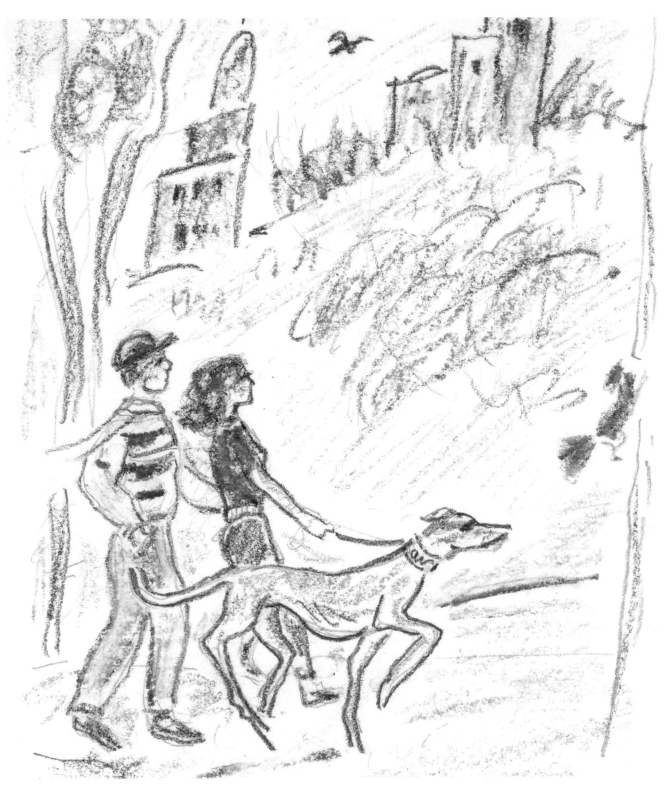

Maple jumps up when Bev's neighbors, Sonny and Karen, come by. They take her for long walks. Sometimes she sees a squirrel and tries to catch it. But she hasn't yet!

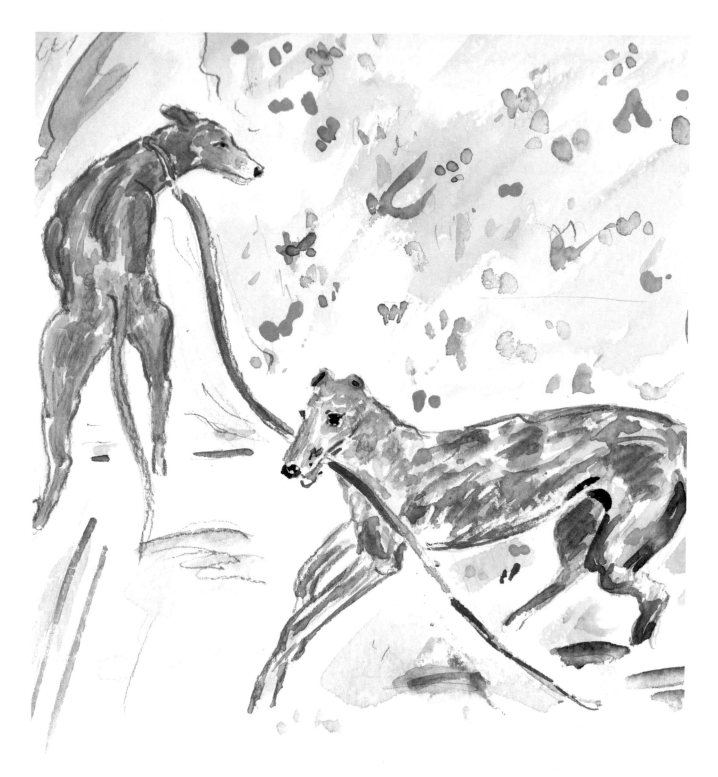

Maple walks with dogs as well as people. Beverly's friends came to visit one evening with Kip, their Vizsla puppy. Kip picked up Maple's leash and proudly led her to the street. Maple looked puzzled and doleful. But always eager to please, she followed Kip.

Maple still visits Dr. Francine for regular checkups. The animal clinic has heavy metal-and-glass doors. Maple is too long to fit easily through the doors.

One sad day, while watching Maple's nose, Beverly did not notice that the tail was still outside the door. The door closed and cut off the end of her tail. Four and a half inches gone!

Now instead of a graceful upward curve, her tail stops and flops down. Poor Maple! She cheerfully learned to live with the cropped tail.

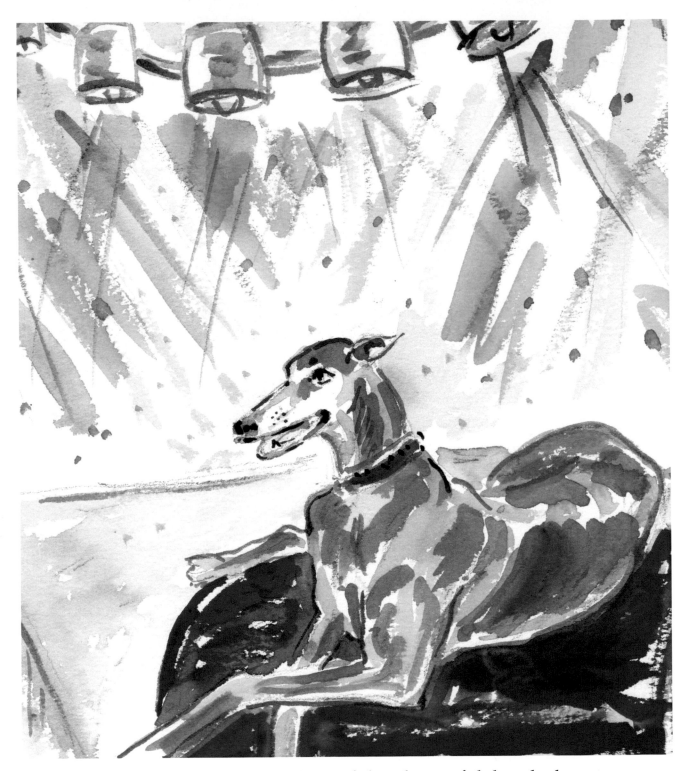

Beverly thinks Maple is the most beautiful and graceful dog she has ever seen. She found a new job for Maple, working as a model at the Cincinnati Art Academy. Just like the dogs of the pharaohs, Maple poses regally for the drawing students.

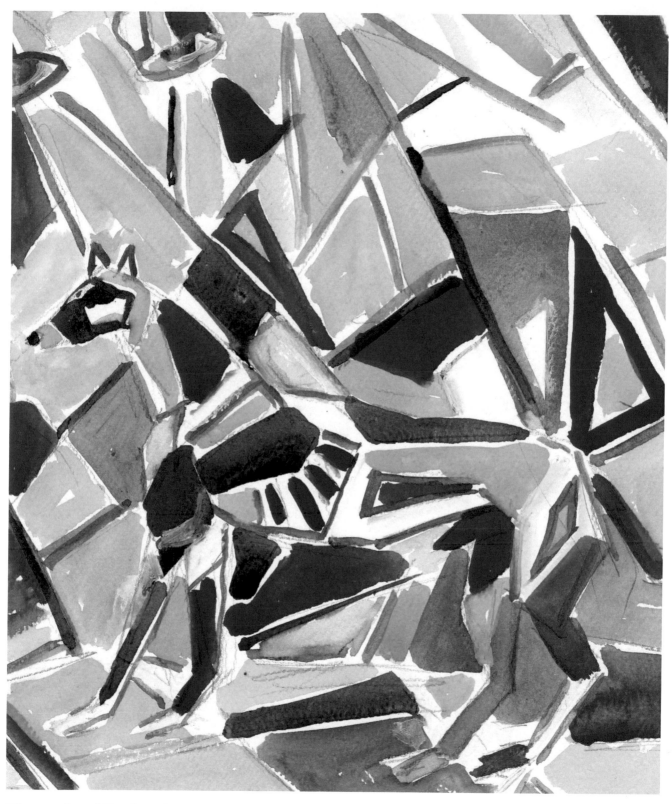

The artists like her because she makes so many beautiful positive and negative shapes. And Maple likes being the center of attention.

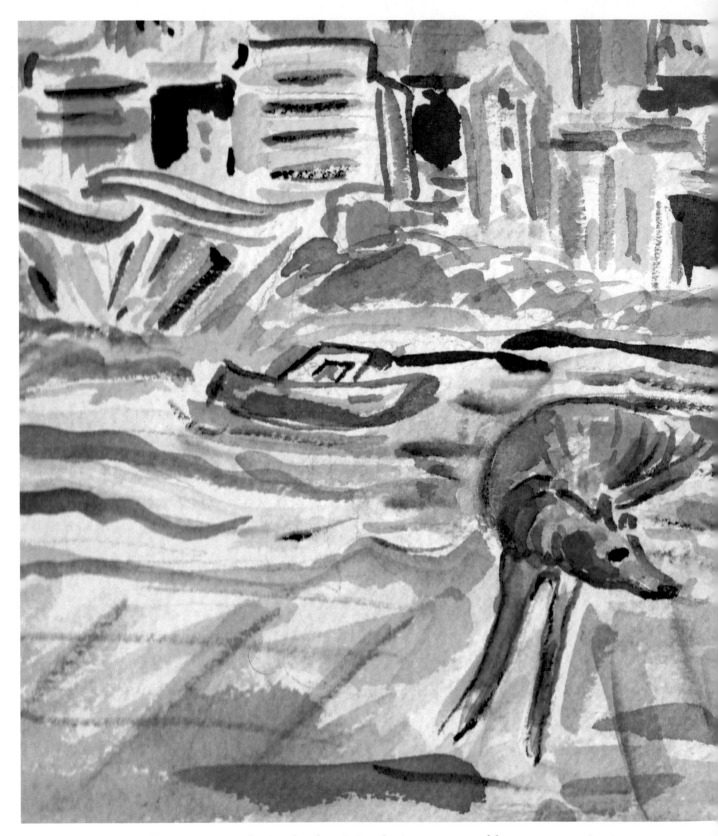

Like the art students, Beverly includes Maple in many of her own paintings.

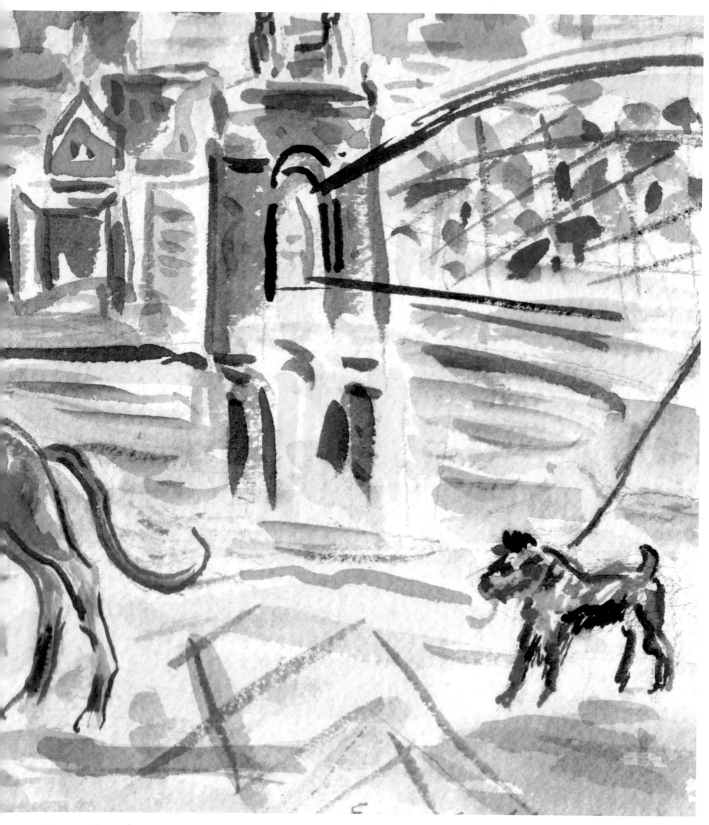

Here she poses in front of the Ohio River and Cincinnati skyline.

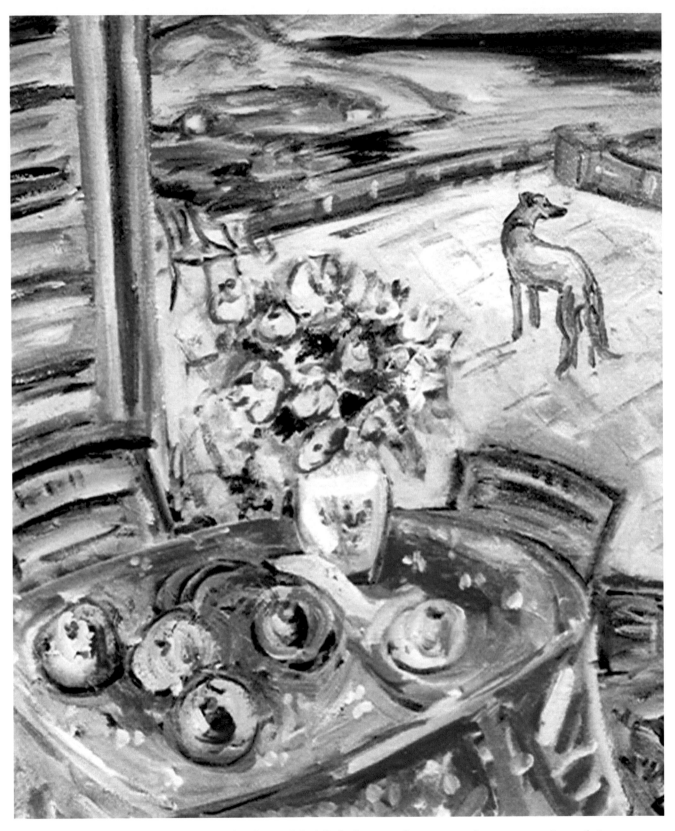

Dog images in art are symbolic of faithfulness, love, and companionship.

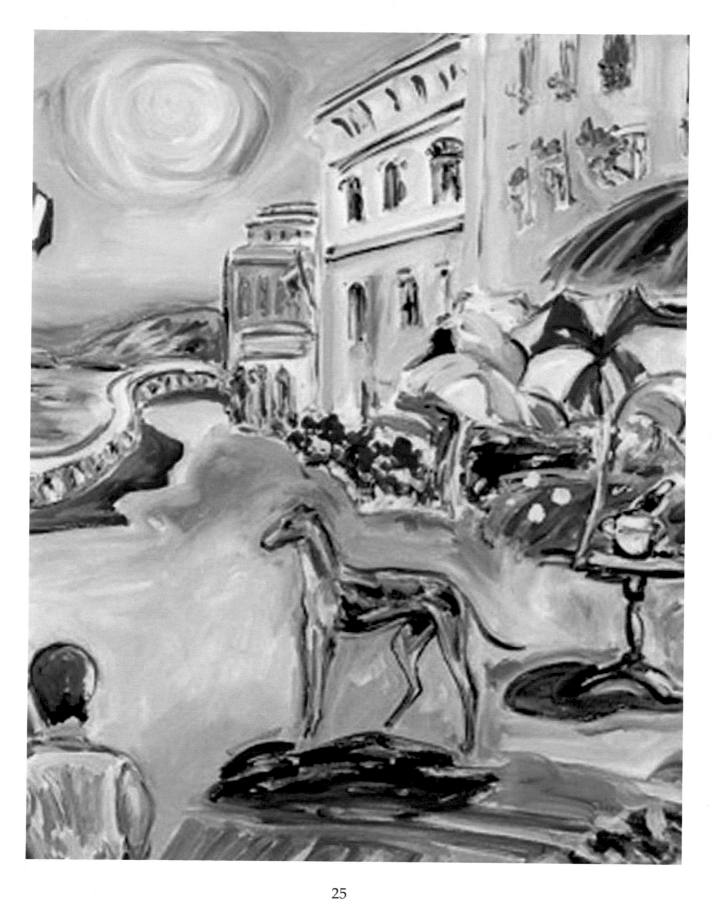

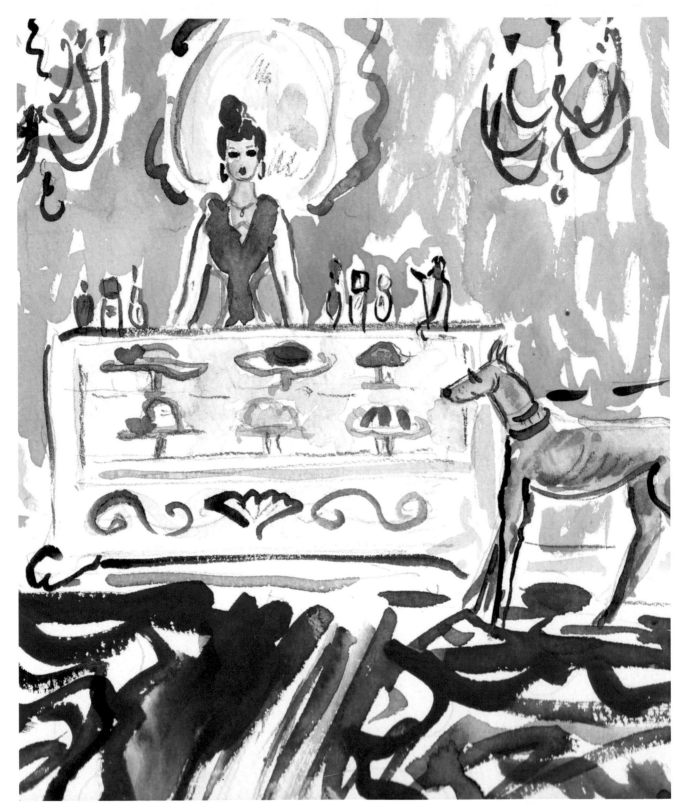

Beverly and Maple visit galleries and boutiques together. With her elegant looks, Maple fits right in.

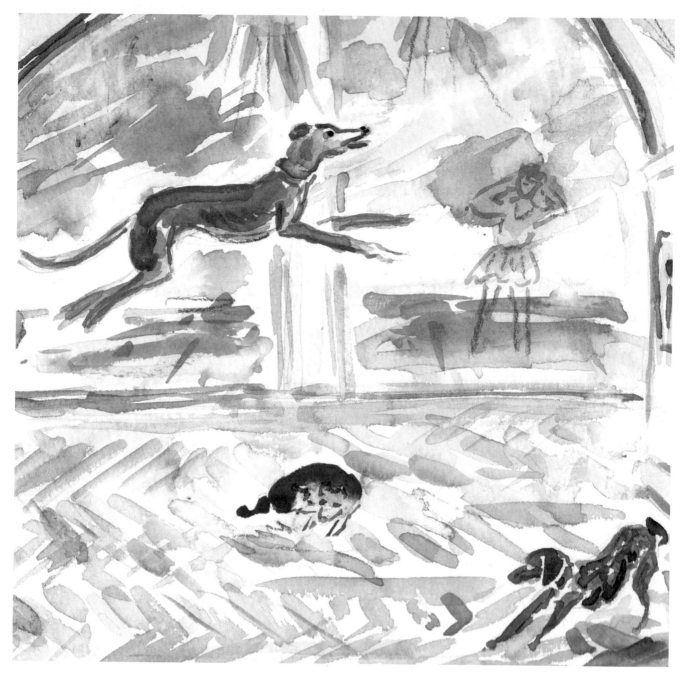

One day Beverly and Maple went to the gallery where Beverly exhibits her paintings. The owners of the gallery have a young poodle named Ginger and an old poodle named Gigi.

Gigi was sleeping soundly in front of the door when Maple and Ginger began racing around the room, jumping over Gigi each time.

A window shopper came in to see what was going on. She said she kept seeing a dog fly by.

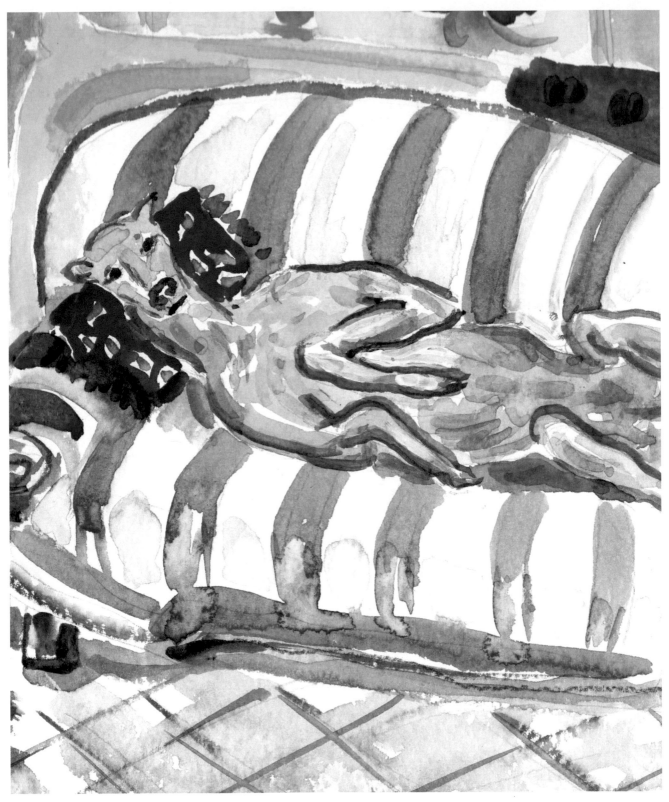

After all her modeling and fun activities, Maple's favorite sport is reclining on the couch. Maple is a forty-five-mile-per-hour couch potato.

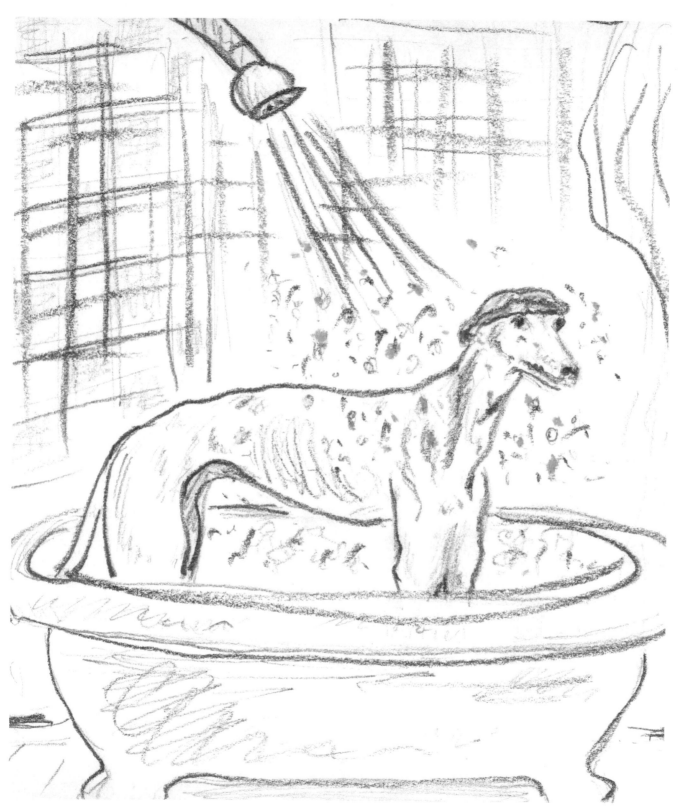

At the end of a long day Maple likes warm, soapy showers, so she can be clean and ready for bed. She looks dignified even when wet.

Greyhounds have extra-thin skin and only one layer of hair. Maple does not like being outdoors for long in cold weather. At Christmastime, she wears a coat to walk in the dog parade as a reindeer. At home, she lies by the fire and waits for Santa.

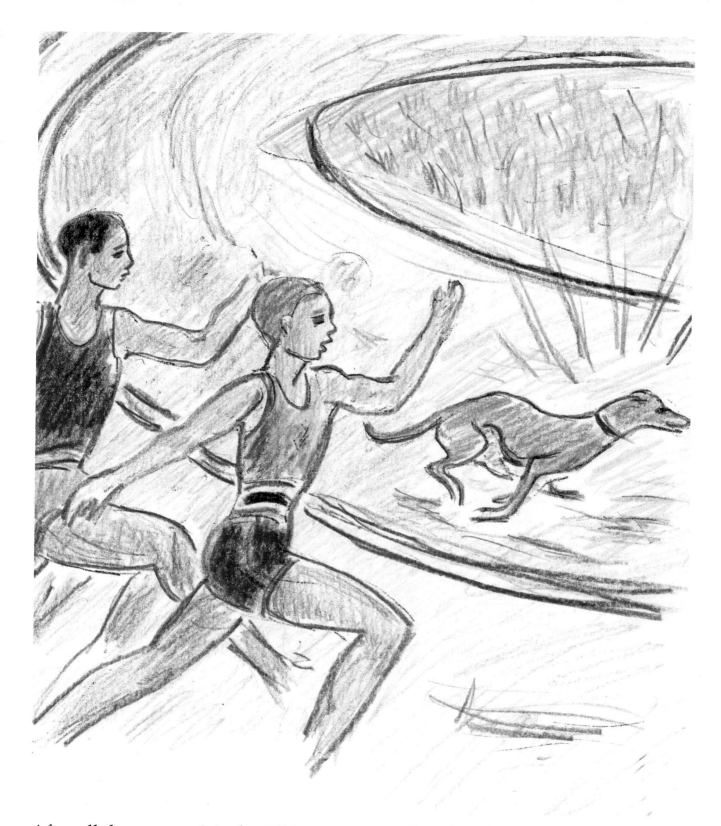

After all these years Maple still loves to race. One day she was able to race with the high school track team. She won!

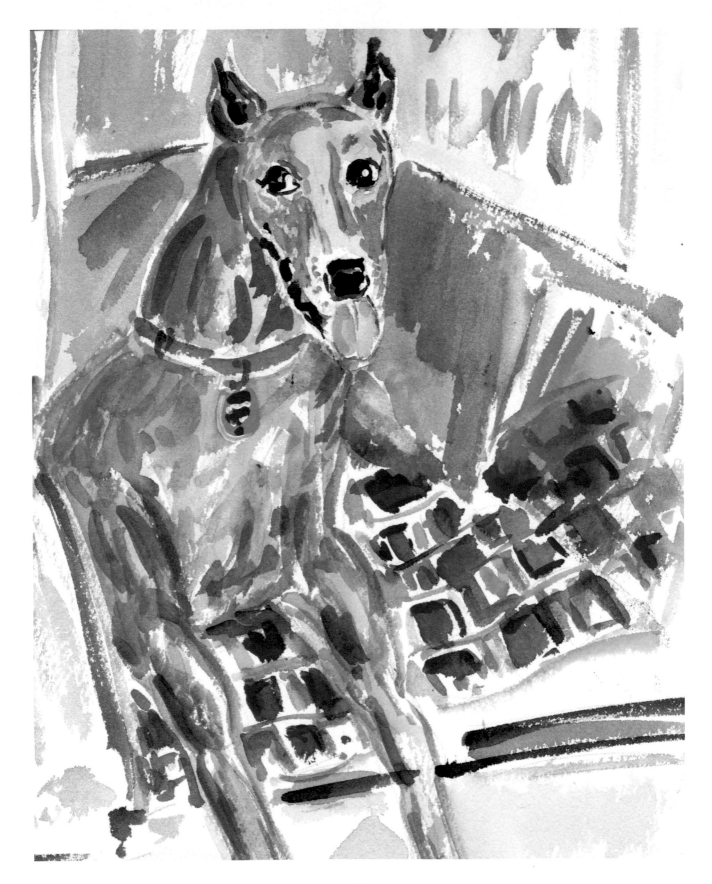

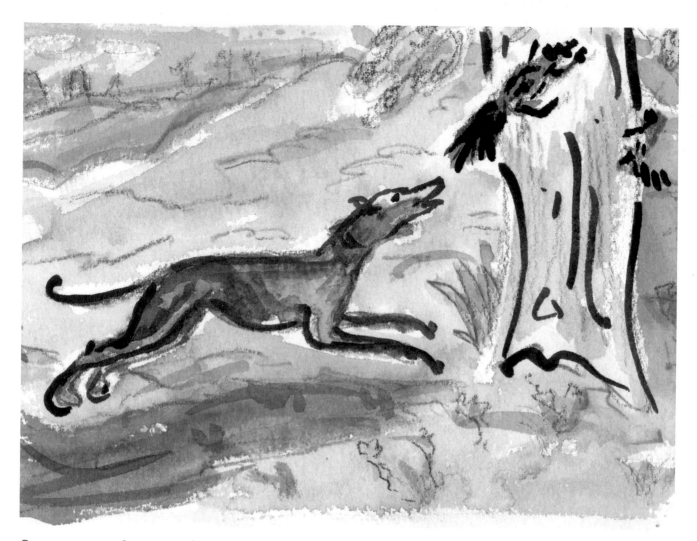

So now you know why Audra and Beverly call Maple the "Lucky Greyhound."

Maple may wake in the morning wondering which house she is in, where she is going to play, whose food and treats she will eat, whose voice she will hear, and whose command she will obey.

But she knows, no matter where she is, she will be cared for and loved by her adopted families. She has trained them all!

But she still can't catch a squirrel!

For more information on local and national greyhound organizations, visit the following sites:

Cincinnati:

Greyhound Adoption of Greater Cincinnati: http://www.cincigreyhounds.org/
Homeward Bound Greyhound Association: http://www.hbgatristate.org/
Queen City Greyhounds: http://www.queencitygreyhounds.org/

Ohio:

Central Ohio Greyhound Rescue: http://www.centralohiogreyhound.org/
Greyhound Adoption of Ohio: http://www.greyhoundadoptionofoh.org/
Team Greyhound Adoption of Ohio: http://www.teamgreyhound.com/

National:

Greyhound Connection: http://www.greyhoundconnection.org/
The Greyhound Project, Inc.: http://www.adopt-a-greyhound.org/
National Greyhound Adoption Program: http://www.ngap.org/index.html
USA Defenders of Greyhounds: http://usadefendersofgreyhounds.org/

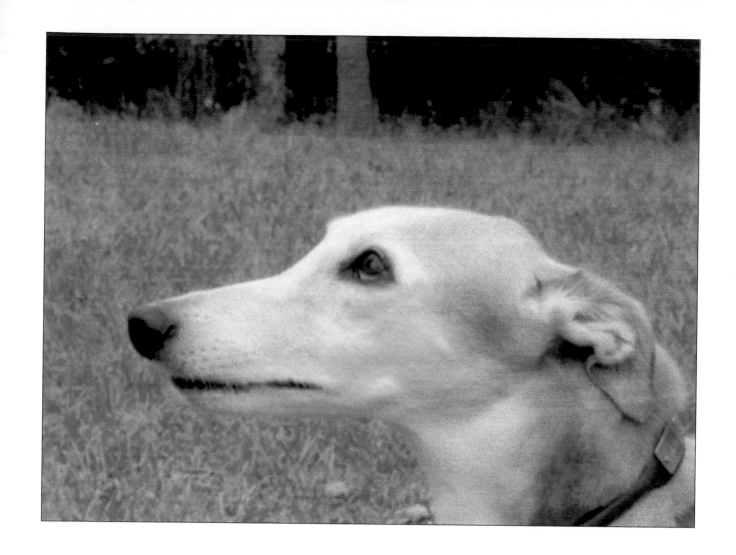

To learn more about Beverly Erschell and her work, visit http://www.erschell.com/.

To purchase additional copies of The Lucky Greyhound, visit cincybooks.com or call 513-382-4315.

About the artist and author

Beverly Erschell lives in Greater Cincinnati. She works in watercolor, acrylic, and oil to produce paintings and drawings on canvas and on paper. Her art is known for its brilliant color, strong form, and intriguing subject matter. Erschell received an associate's degree in the arts from Stephen's College in Columbia, Missouri. She attended the Cincinnati Art Academy and the University of Cincinnati, receiving a BFA and MFA in Fine Art from UC's College of Design, Architecture and Art.

Erschell's paintings are in the permanent collections of Cincinnati Art Museum and numerous corporate collections. Her work has been featured in exhibitions at the Contemporary Art Center of Cincinnati, the Dayton Art Museum, and the Weston Art Gallery in Cincinnati.

About writing the book

"I wrote this book to tell the story of our experience with a pet greyhound, an unusual breed of dog that isn't commonly seen in everyday life. Maple opened a whole new world of history, people, enlightenment, and inspiration. The bookstore where I often took Maple—although she couldn't read—suggested that I write a book on greyhounds because there were few out there. So I drew and wrote about every funny experience that Audra, Maple, and I had together. Dogs can't talk, but they certainly can communicate"

Beverly Helmbold Erschell

www.BeverlyErschell.com